D0046313

The Book of Days

The Book of Days

NATIONAL GALLERY OF ART

GALISON BOOKS
GMG Publishing, New York

Cover Illustration
Claude Monet
The Artist's Garden at Vétheuil
Ailsa Mellon Bruce Collection.

Copyright 1983 in all countries
of the International Copyright Union
by GMG Publishing Corp.
All rights reserved.

A Galison Book
Published by GMG Publishing Corp.
25 West 43rd Street
New York, NY 10036

ISBN 0-939456-05-2

Publisher: Gerald Galison
Desinger: Marilyn Rose
Editor: Maureen McNeil
Production: Randi Wasserman
Printed in Japan

All reproductions are details
of drawings and paintings from
the National Gallery of Art.

\mathcal{W}elcome to the new National Gallery of Art **Book of Days,** a combined "anniversary book" and collection of masterpiece art reproductions.

Note that for each day of the year, the month and date are indicated, but not the day. This makes it perfect for noting special dates, birthdays, and anniversaries which repeat from year to year. And it makes remembering these occasions a delightful art experience.

As a memento of the Gallery it is very special. It includes seventy three examples of the highlights of the collection.

$\mathscr{Introduction}$

The collections of the National Gallery of Art, created from the generosity of over four hundred private donors, represent the major schools in Western European art since the thirteenth century and American art from colonial times to the present. Most are the fruits of an American age when prosperity allowed citizens of a young, traditionless country to gather examples from the artistic and cultural traditions of their forebears.

The original structure of the National Gallery of Art, now called the West Building, was the gift to the nation by former Secretary of the Treasury and Ambassador to the Court of St. James, Andrew W. Mellon. During the 1920s Mr. Mellon had begun assembling a collection of fine art with the intention of forming a national gallery in Washington, D.C. His collection of 126 paintings and 26 pieces of sculpture was given to the nation in 1937, the year of his death.

On March 24, 1937, the National Gallery was officially established by a Joint Resolution of Congress. Although formally established as a bureau of the Smithsonian Institution, it is an autonomous organization maintained by the federal government. It is governed by its own board of trustees, members of which include the Chief Justice of the United States, the Secretary of the Smithsonian Institution, and the Secretaries of State and the Treasury, all ex officio, and five distinguished private citizens.

The Gallery's West Building was accepted by President Franklin D. Roosevelt for the people of the United States in 1941. Constructed with funds from the A.W. Mellon Educational and Charitable Trust, it is an impressive neoclassical structure that provides appropriate settings for works by old masters. Its architect was John Russell Pope, who also

designed the Jefferson Memorial and the National Archives. The exterior is rose-white Tennessee marble, and the columns in the rotunda were quarried in Tuscany, Italy. Inside, largely native stone decorates the 500,000 square feet of floor space.

Within a generation's time, the National Gallery found it needed to expand. Plans were made to use the trapezoidal plot of land adjacent to the West Building where the Mall and Pennsylvania Avenue converge near the foot of Capitol Hill. The last major undeveloped site on Pennsylvania Avenue, the land had been set aside by Congress in 1937 for the Gallery's future use. Funds for this new building were provided by Paul Mellon and the late Ailsa Mellon Bruce, son and daughter of the donor of the Gallery's West Building, and by The Andrew W. Mellon Foundation.

The location and shape of the site posed several challenges. Located on the inaugural route between the Capitol and the White House, any building constructed there had to be appropriately monumental in scale. The structure also had to abide by the set-back lines established by the National Capital Planning Commission and relate in size to the other buildings along Pennsylvania Avenue and the Mall, especially the Gallery's West Building.

The architects, I.M. Pei and Partners of New York, resolved the problem by cutting the trapezoid into two triangular sections: the larger triangle containing public galleries and the smaller unit housing administrative and curatorial offices and the Center for Advanced Study in the Visual Arts. As a result, the public galleries of the West and East Buildings align on a single axis. And, although boldly different, the contemporary and classical architectural designs are identical in texture and material. In time, the marble facings of the East Building will mellow to the same rose tone of the West.

The East Building was opened on June 1, 1978, to offer a wide variety of art experiences, especially providing for the first time space for contemporary art. "The new building is not a museum of contemporary art," stated the museum's director J. Carter Brown, "but since the National Gallery is an anthology, it cannot stop at any capricious moment in history." The intent is to include definitive modern works so that the progression from medieval times to the present is uninterrupted.

January

1

2

3

4

5

Claude Monet: *Bazille and Camille*
Signed, 1865/1866. 36⅝ x 27⅛". Ailsa Mellon Bruce Collection.

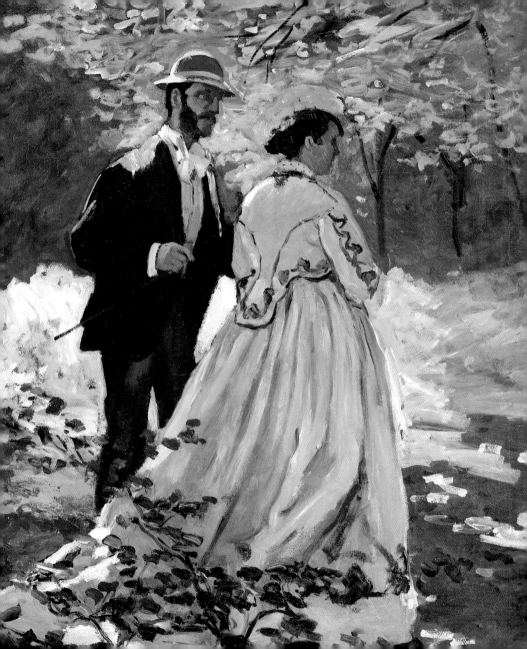

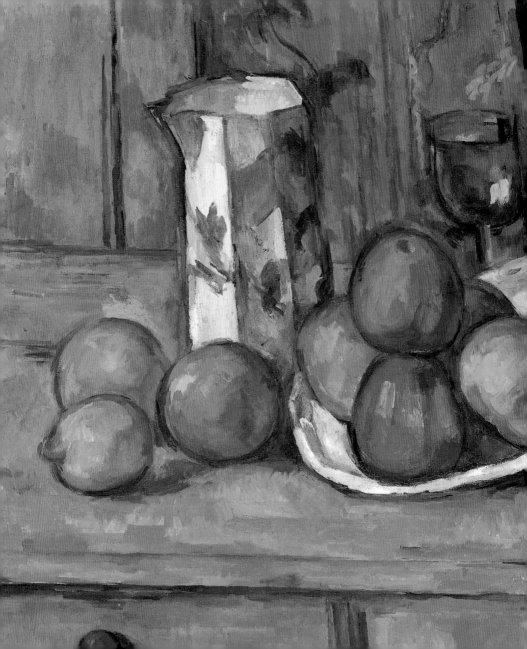

January

6

7

8

9

10

Paul Cézanne: *Still Life*
c. 1900. 18 x 21⅝". Gift of the W. Averell Harriman Foundation
in memory of Marie N. Harriman.

January

11

12

13

14

15

Rembrandt van Ryn: *The Mill*
c. 1650. 34½ x 41½". Widener Collection.

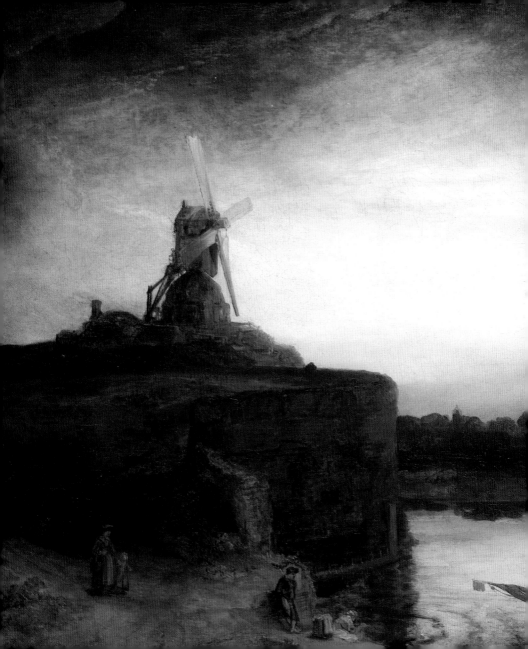

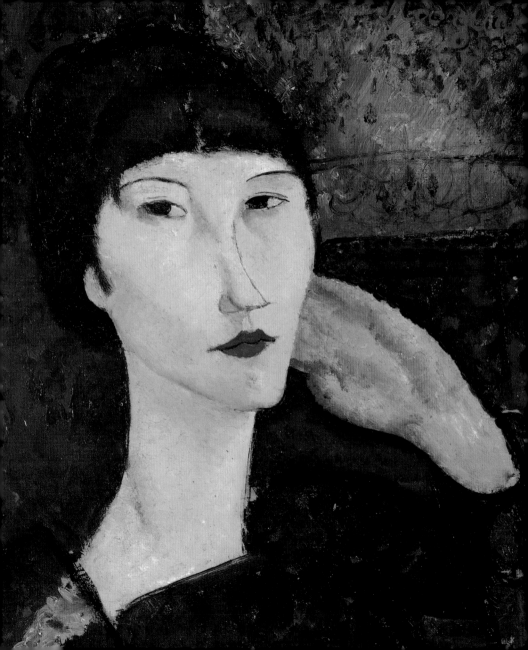

January

16

17

18

19

20

Amedeo Modigliani: *Adrienne (Woman With Bangs)*
Signed, 1917. 21¾ x 15". Chester Dale Collection.

January

21

22

23

24

25

Henri Rousseau: *Rendezvous in the Forest*
Signed, 1889. 36¼ x 28¾". Gift of the W. Averell Harriman
Foundation in memory of Marie N. Harriman.

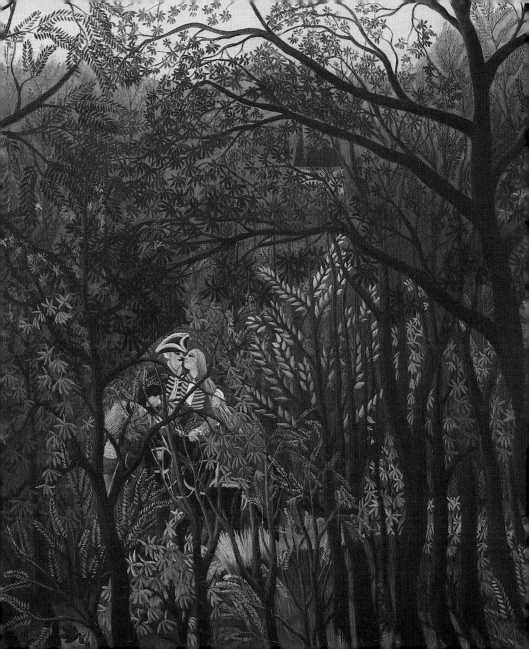

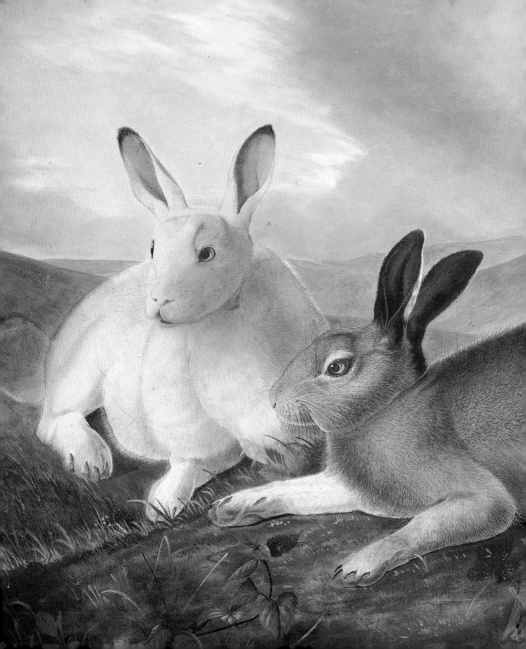

January

26

27

28

29

30

John James Audubon: *Arctic Hare*
c. 1841. 24½ x 34¼". Gift of E.J.L. Hallstrom

Jan./Feb.

31

1

2

3

4

Robert Delaunay: *Political Drama*
Signed, 1914. 35 x 26''. Gift of the Joseph H. Hazen Foundation, Inc.

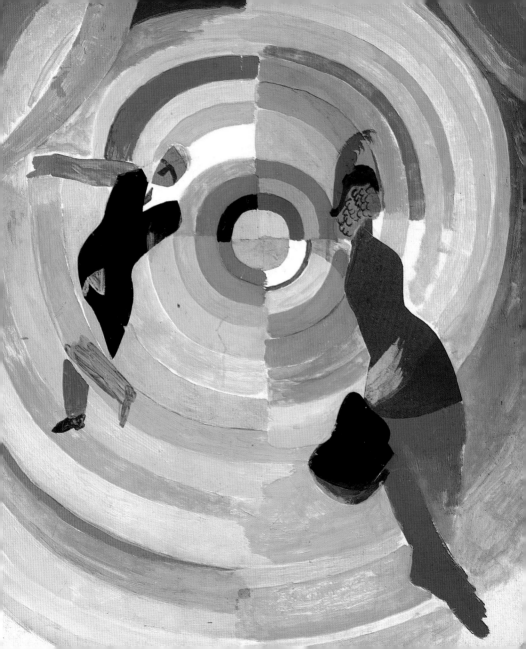

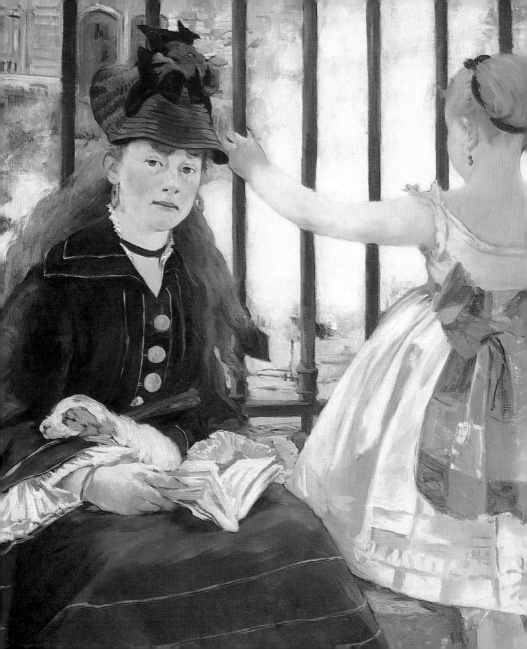

February

5

6

7

8

9

Edouard Manet: *Gare Saint-Lazare*
Signed, 1873. 36¾ x 45⅛". Gift of Horace Havemeyer
in memory of his mother, Louisine W. Havemeyer.

February

10

11

12

13

14

Childe Hassam: *Allies Day, May 1917*
Signed, 1917. 36¾ × 30¼". Gift of Ethelyn McKinney in
memory of her brother, Glenn Ford McKinney.

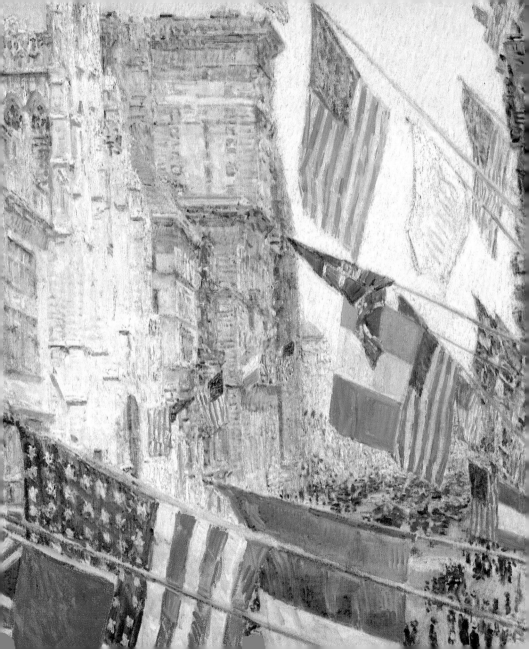

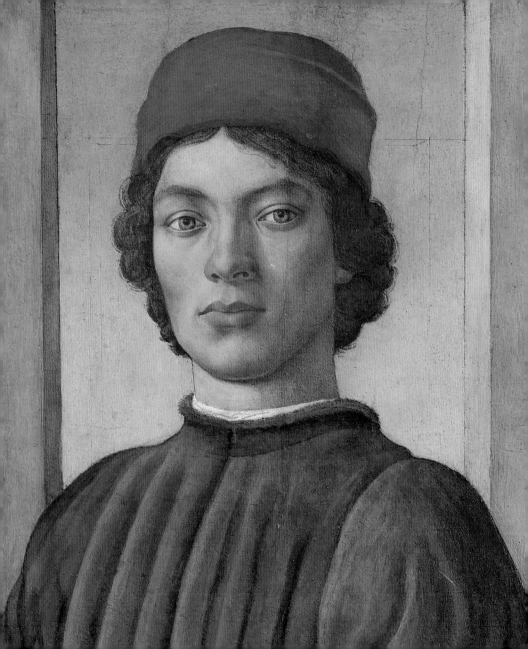

15

16

17

18

19

Filippino Lippi: *Portrait of a Youth*
c. 1485. 20 x 13⅞". Andrew W. Mellon Collection.

February

20

21

22

23

24

Winslow Homer: *Sketch for Hound and Hunter*
1892. 13 15/16 x 19 13/16". Gift of Ruth K. Henschel
in memory of her husband, Charles R. Henschel.

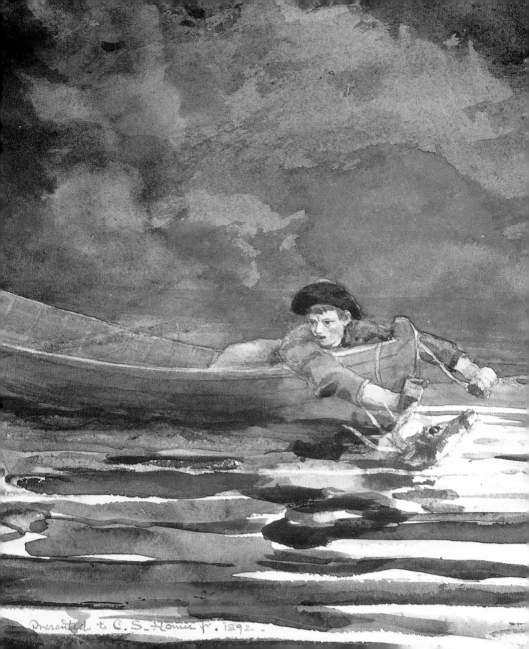

Presented to C. S. Homer Jr. 1292.

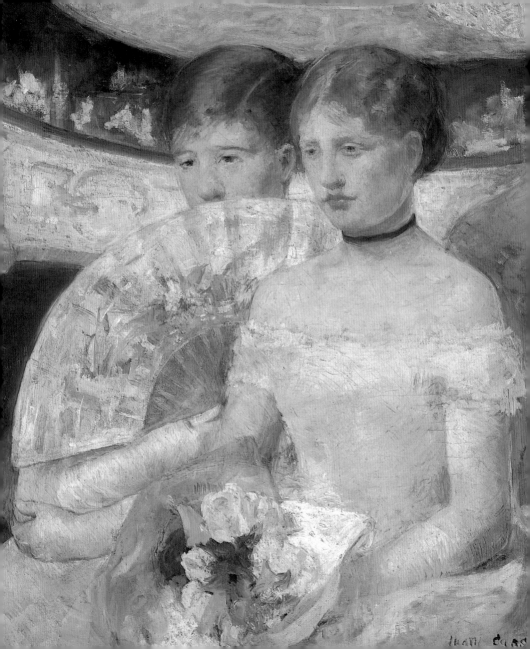

25

26

27

28/29

1

Mary Cassatt: *The Loge*
Signed, 1882. 31½ x 25⅛". Chester Dale Collection.

March

2

3

4

5

6

Jean-Auguste Dominique Ingres: *Ulysses*
Signed, c. 1827. 9¾ x 7¼". Chester Dale Collection.

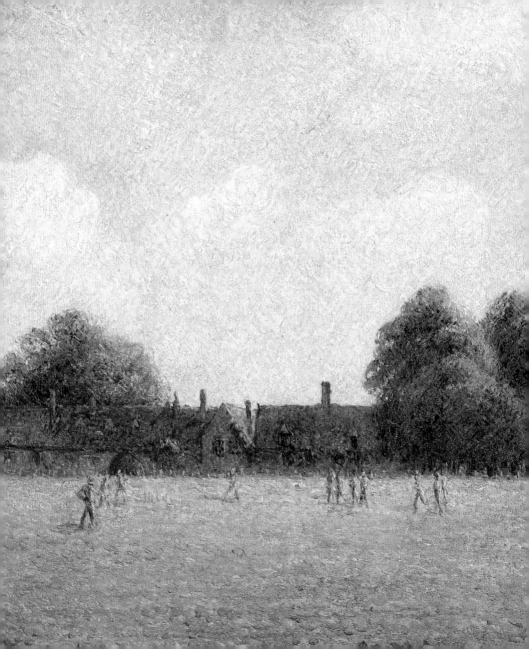

March

7

8

9

10

11

Camille Pissarro: *Hampton Court Green*
Signed, 1891. 21⅜ x 28¾". Ailsa Mellon Bruce Collection.

March

12

13

14

15

16

Berthe Morisot: *The Mother and Sister of the Artist*
1869-1870. 39¾ x 32¼″. Chester Dale Collection.

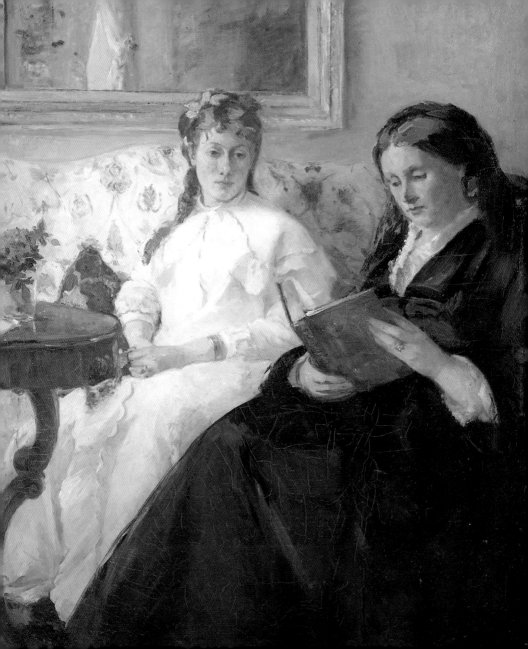

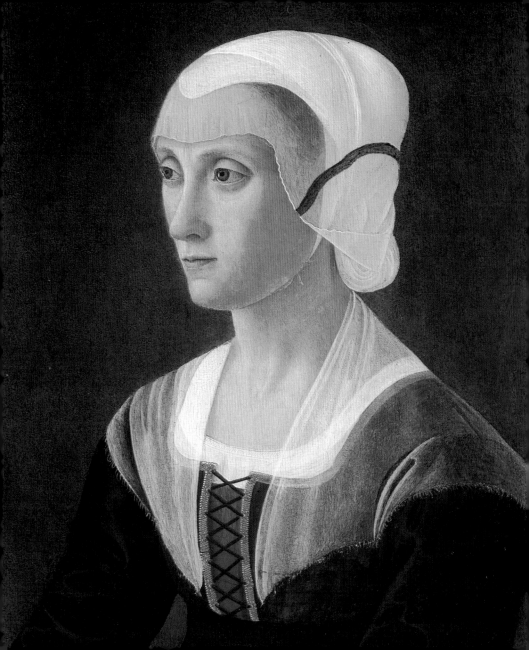

March

17

18

19

20

21

Domenico Ghirlandaio: *Lucrezia Tornabuoni*
Toward 1475. 21 x 15¾". Samuel H. Kress Collection.

March

22

23

24

25

26

Thomas Moran: *The Much Resounding Sea*
Signed, 1884. 25 x 62″. Gift of the Avalon Foundation.

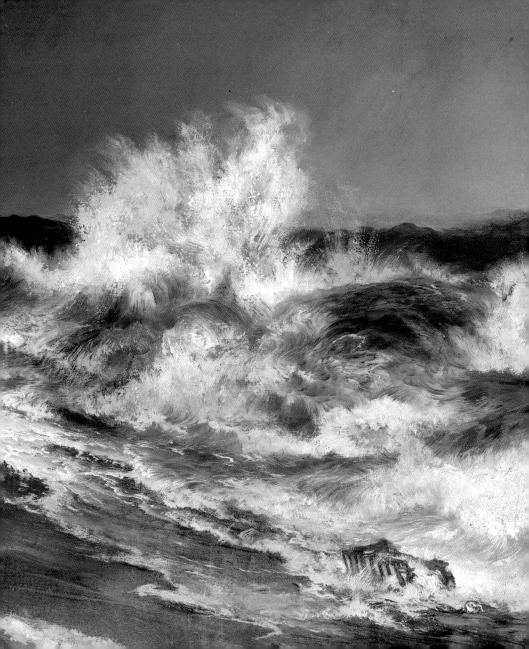

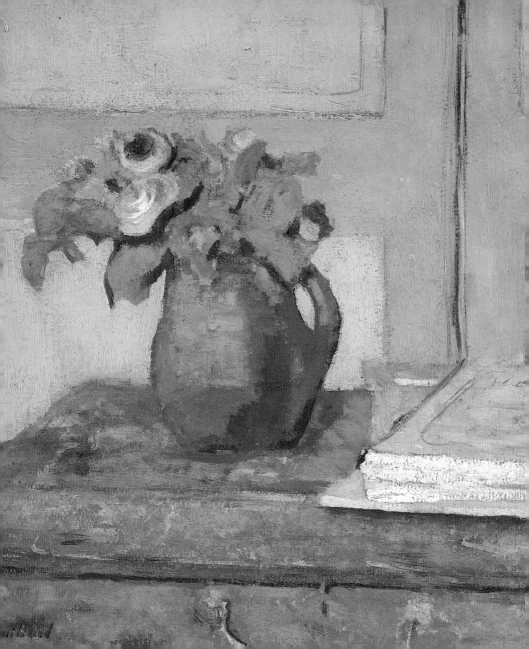

March

27

28

29

30

31

Edouard Vuillard: *The Artist's Paint Box and Moss Roses*
Signed, 1898. 14¼ x 16⅞". Ailsa Mellon Bruce Collection.

April

1

2

3

4

5

Maurice Utrillo: *Street at Corté, Corsica*
Signed, 1913. 24 x 31¾". Ailsa Mellon Bruce Collection.

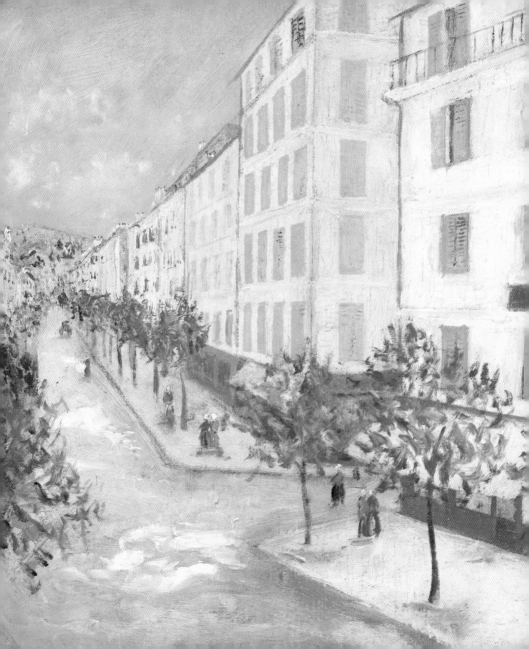

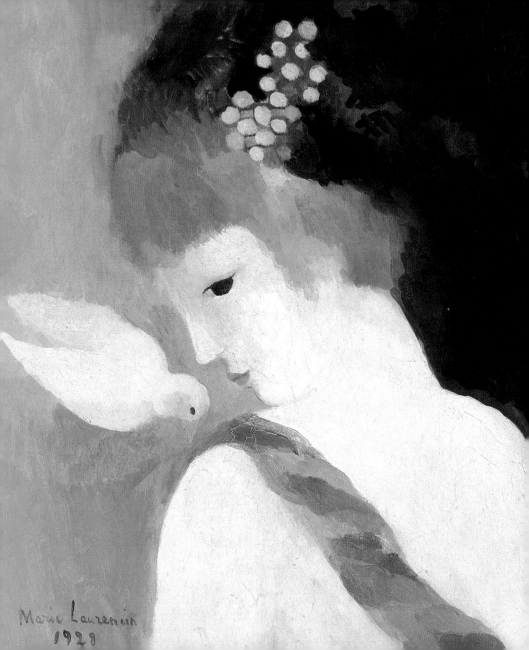

Marie Laurencin
1928

6

7

8

9

10

Marie Laurencin: *Girl with a Dove*
Signed, 1928. 18¼ × 15⅛″. Chester Dale Collection.

April

11

12

13

14

15

Masolino da Panicale: *The Archangel Gabriel*
Probably c. 1420/1430. 30 x 22⅛". Samuel H. Kress Collection.

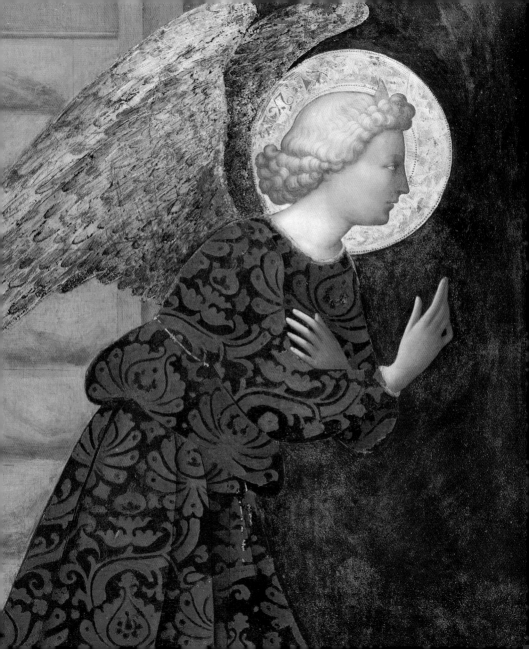

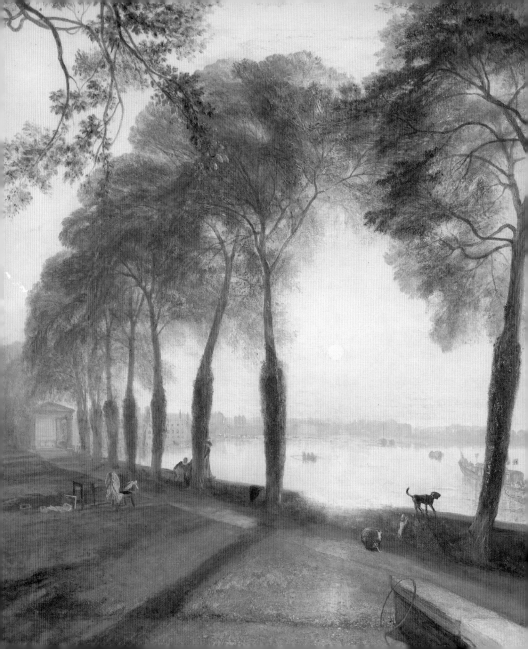

April

16

17

18

19

20

J.M.W. Turner: *Mortlake Terrace*
c. 1826. 36¼ x 48⅛". Andrew W. Mellon Collection.

April

21

22

23

24

25

Edouard Manet: *A King Charles Spaniel*
Signed, c. 1866. 18¼ x 15". Ailsa Mellon Bruce Collection.

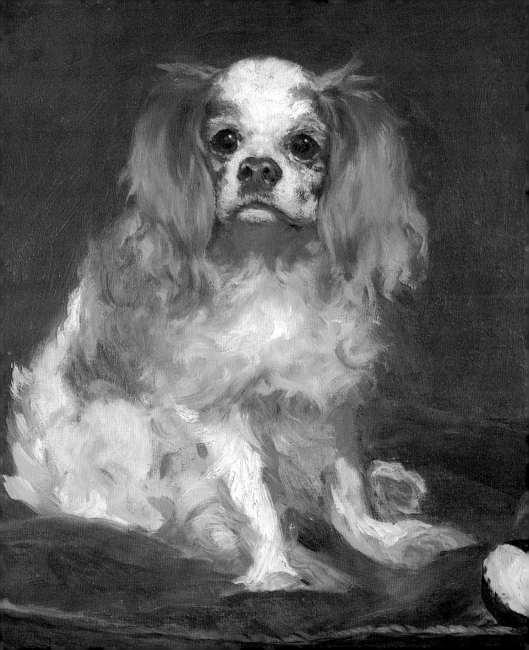

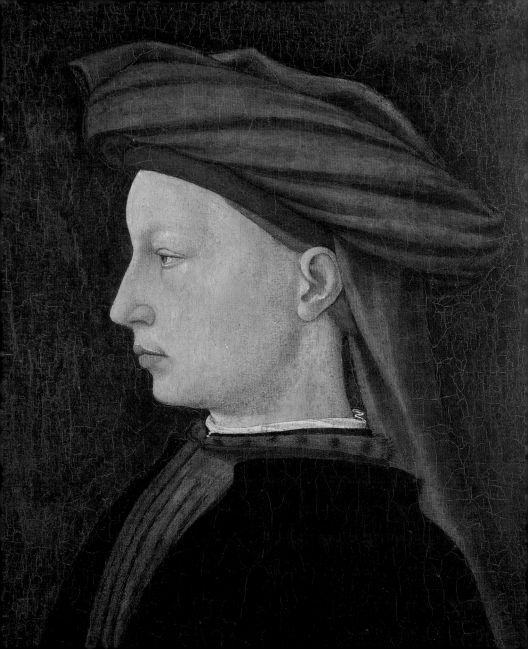

26

27

28

29

30

Masaccio: *Profile Portrait of a Young Man*
c. 1425. 16⅝ x 12¾". Andrew W. Mellon Collection.

May

1

2

3

4

5

Georges Seurat: *Seascape at Port-en-Bessin, Normandy*
Signed, 1888. 25⅝ x 31⅞". Gift of the W. Averell Harriman Foundation
in memory of Marie N. Harriman.

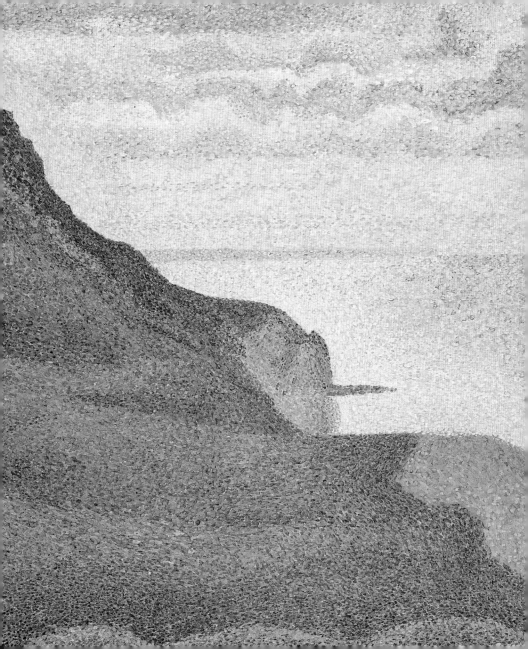

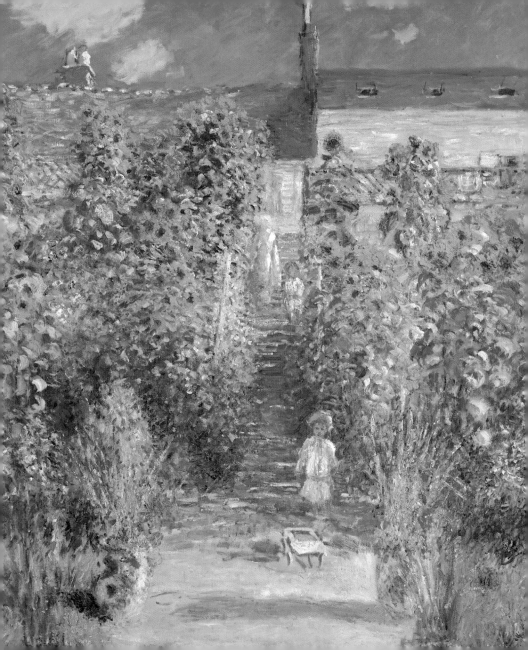

May

6

7

8

9

10

Claude Monet: *The Artist's Garden at Vétheuil*
Signed, 1880. 59⅝ × 47⅝". Ailsa Mellon Bruce Collection.

May

11

12

13

14

15

George Romney: *Miss Willoughby*
1781 - 1783. 36¼ x 28". Andrew W. Mellon Collection.

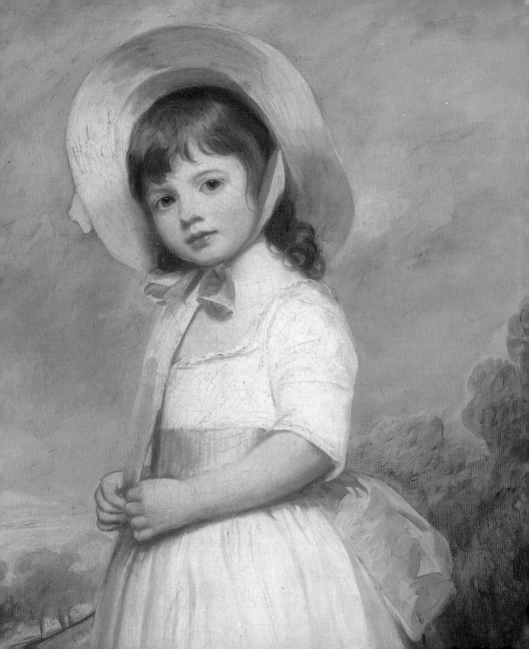

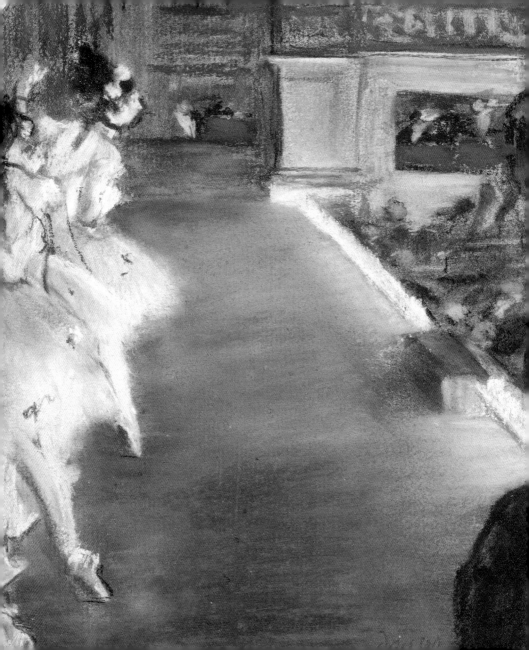

May

16

17

18

19

20

Edgar Degas: *Dancers at the Old Opera House*
Signed, c. 1877. 8⅝ x 6¾". Ailsa Mellon Bruce Collection.

May

21

22

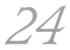23

24

25

Edgar Degas: *Madame Camus*
1869/1870. 28⅝ x 36¼". Chester Dale Collection.

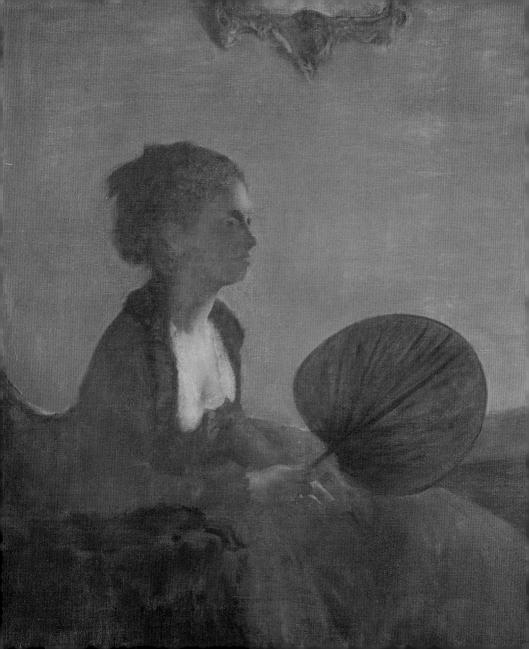

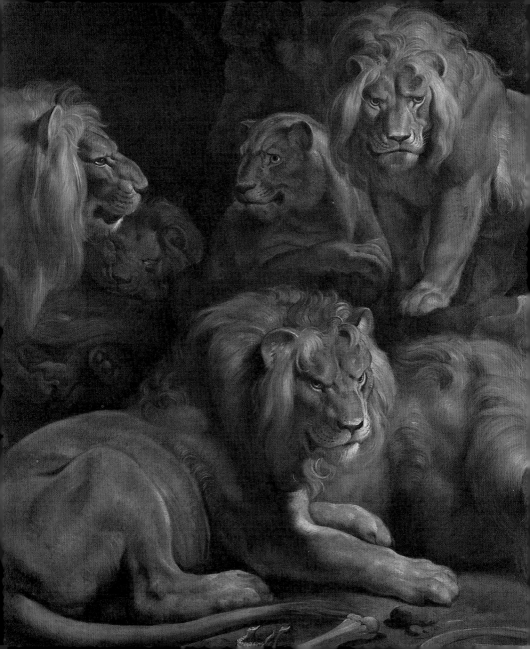

May

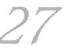

28

29

Peter Paul Rubens: *Daniel in the Lions' Den*
c. 1615. 88¼ x 130⅛". Ailsa Mellon Bruce Fund.

May/June

31

1

2

3

4

Paul Cézanne: *Le Château Noir*
1900/1904. 29 x 38". Gift of Eugene and Agnes Meyer.

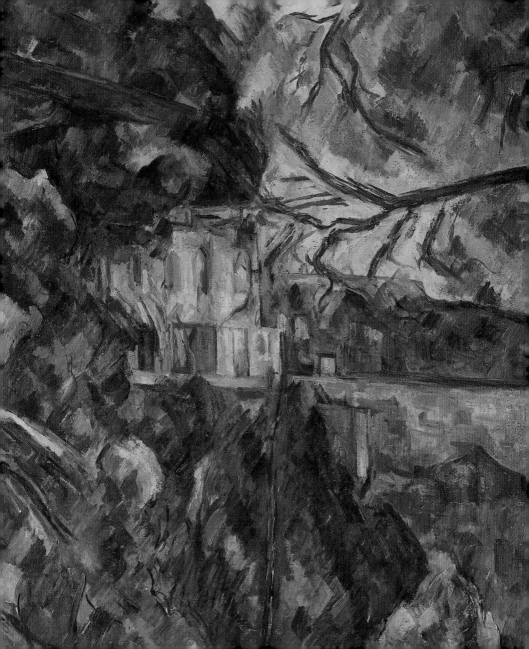

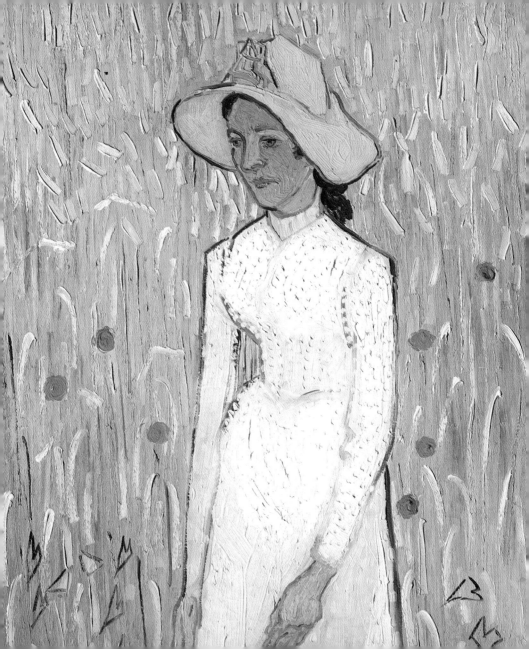

June

5

6

7

8

9

Vincent van Gogh: *Girl in White*
1890. 26⅛ x 17⅞". Chester Dale Collection.

June

10

11

12

13

14

Camille Pissarro: *The Artist's Garden at Eragny*
Signed, 1898. 29 x 36⅜". Ailsa Mellon Bruce Collection.

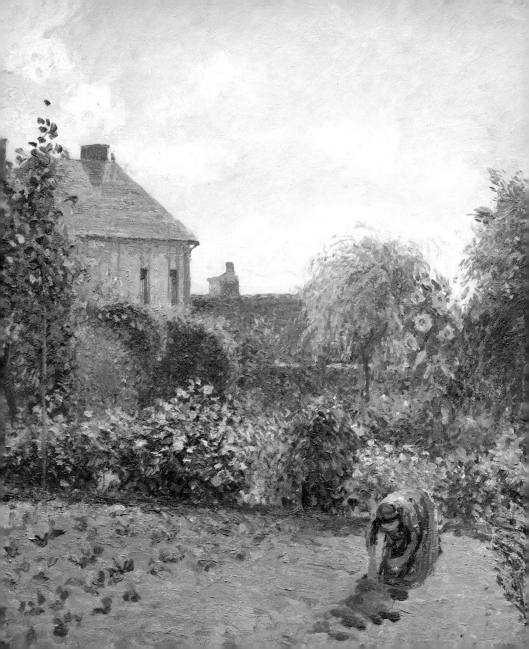

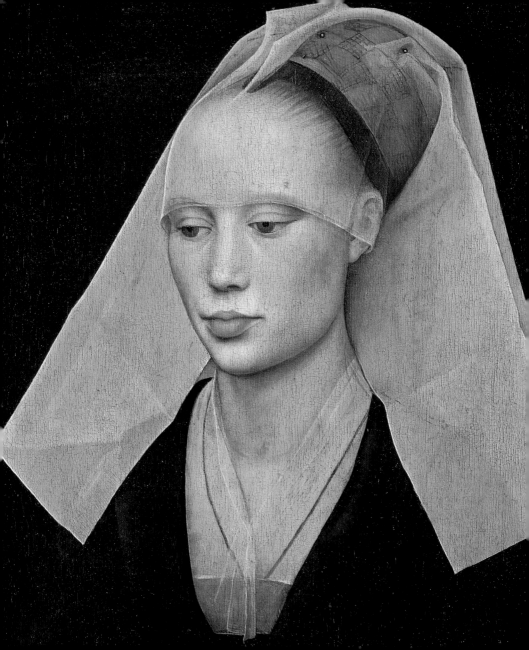

June

15

16

17

18

19

Rogier van der Weyden: *Portrait of a Lady*
c. 1455. 14½ x 10¾". Andrew W. Mellon Collection.

June

20

21

22

23

24

Pierre Bonnard: *The Cab Horse*
Signed, c. 1895. 11¾ x 15¾". Ailsa Mellon Bruce Collection.

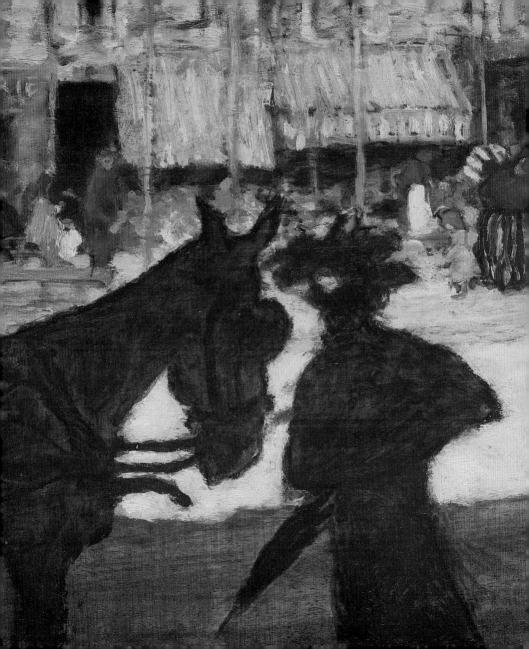

June

25

26

27

28

29

Pablo Picasso: *Pedro Mañach*
Signed, 1901. 41½ x 27½″. Chester Dale Collection.

June / July

30

1

2

3

4

Auguste Renoir: *Regatta at Argenteuil*
1874. 12¾ x 18″. Ailsa Mellon Bruce Collection.

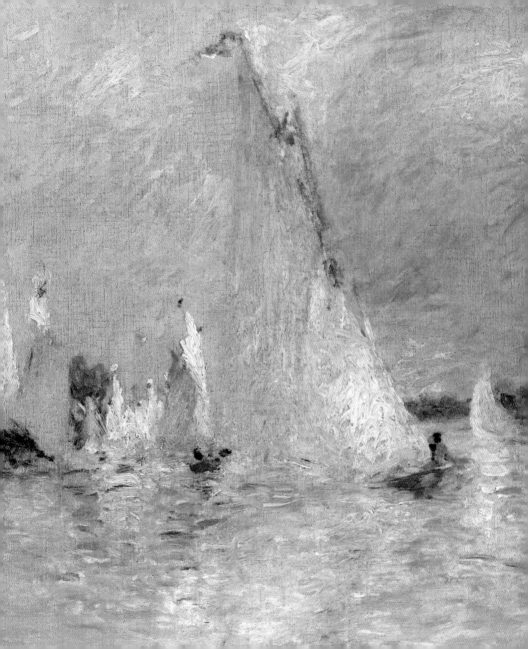

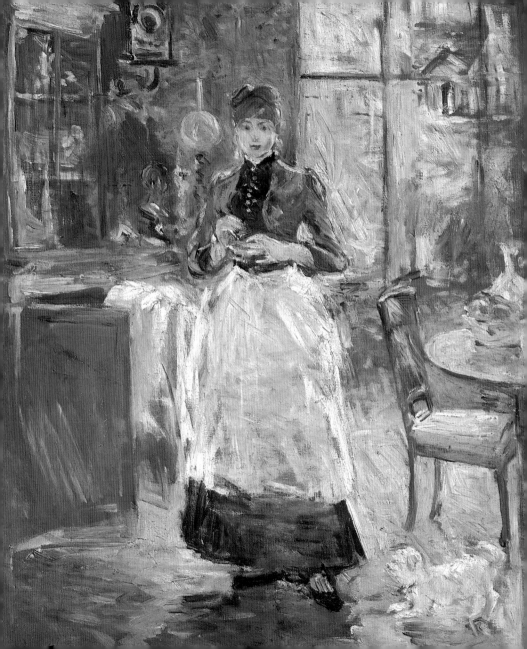

July

5

6

7

8

9

Berthe Morisot: *In the Dining Room*
Signed, 1886. 24⅛ x 19¾". Chester Dale Collection.

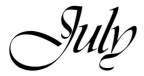
July

10

11

12

13

14

Pierre Bonnard: *Bouquet of Flowers*
Signed, c. 1908. 27⅝ x 18⅝″. Ailsa Mellon Bruce Collection.

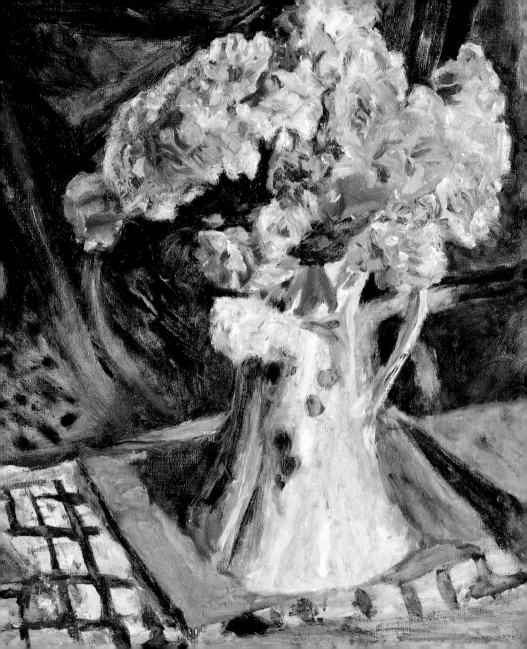

July

15

16

17

18

19

Camille Pissarro: *The Bather*
Signed, 1895. 13⅞ x 10¾". Chester Dale Collection.

July

20

21

22

23

24

Domenico Veneziano: *Madonna and Child*
c. 1445. 32½ x 22¼″. Samuel H. Kress Collection.

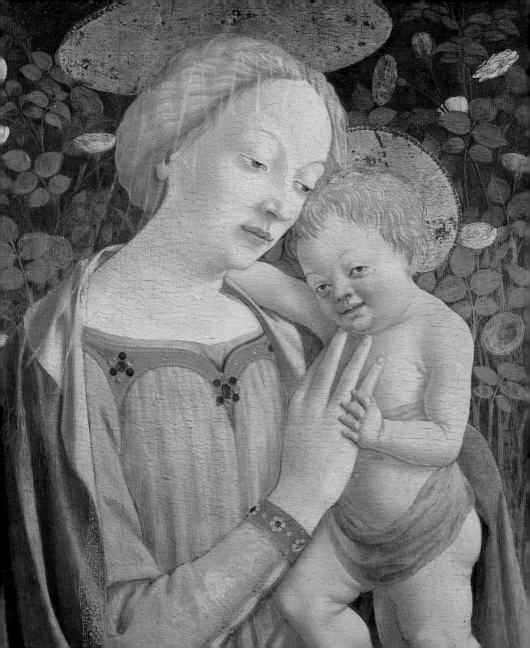

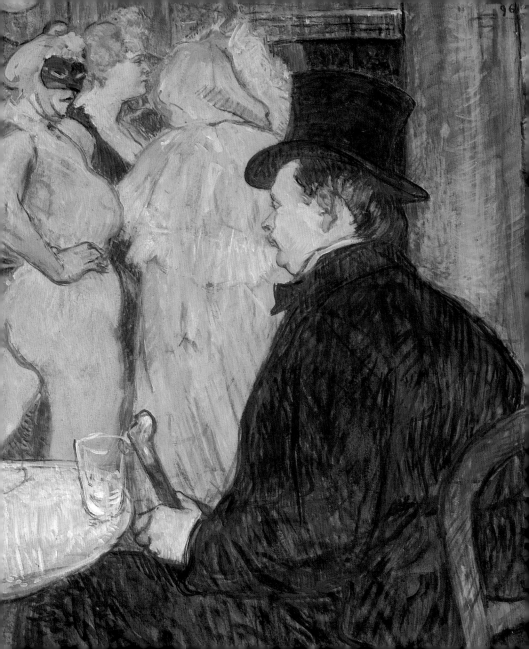

25

26

27

28

29

Henri de Toulouse-Lautrec: *Maxime Dethomas*
Signed, 1896. 26¾ x 20¾". Chester Dale Collection.

July/Aug.

30

31

1

2

3

John Marin: *Woolworth Building No. 29*
Signed, 1912. 19¾ x 15¾". Gift of Eugene and Agnes Meyer.

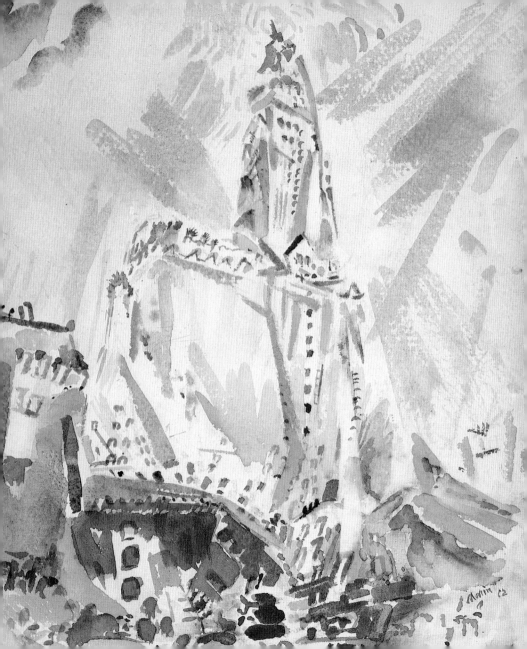

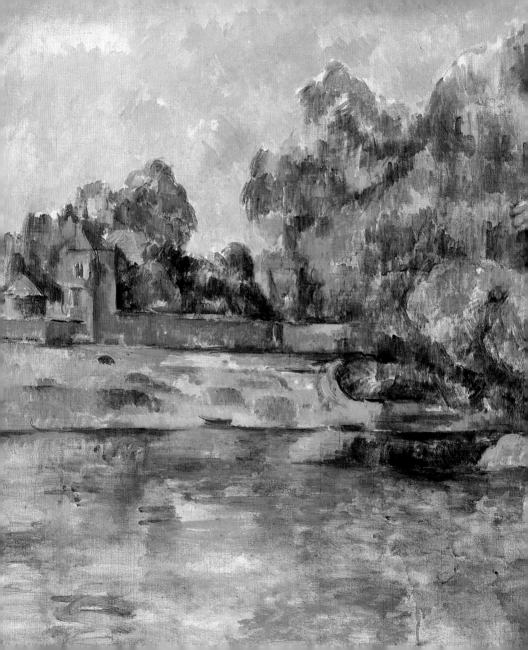

August

4

5

6

7

8

Paul Cézanne: *Riverbank*
c. 1895. 28¾ x 36⅜". Ailsa Mellon Bruce Collection.

August

9

10

11

12

13

William Glackens: *Family Group*
1910/1911. 72 x 84″. Gift of Mr. and Mrs. Ira Glackens.

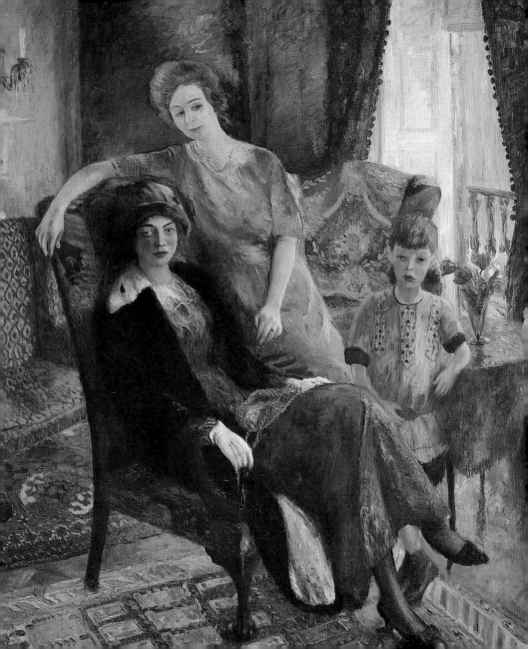

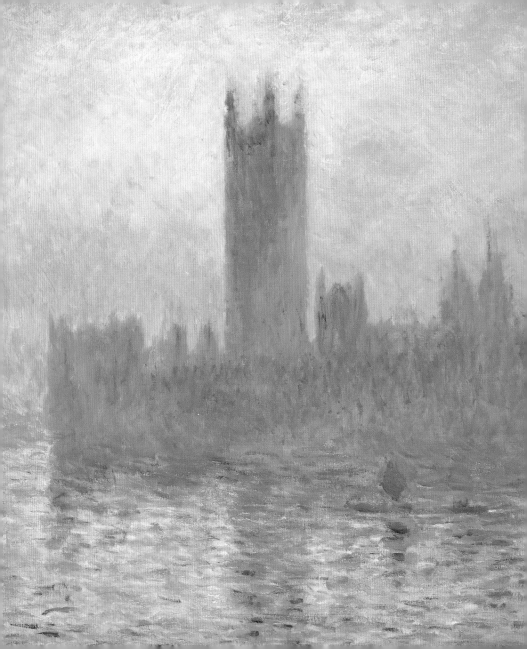

August

14

15

16

17

18

Claude Monet: *The Houses of Parliament, Sunset*
Signed, 1903. 32 x 36⅜". Chester Dale Collection.

August

19

20

21

22

23

Paul Cézanne: *Man With Pipe*
1892/1896. 10¼ x 8″. Gift of the W. Averell Harriman
Foundation in memory of Marie N. Harriman.

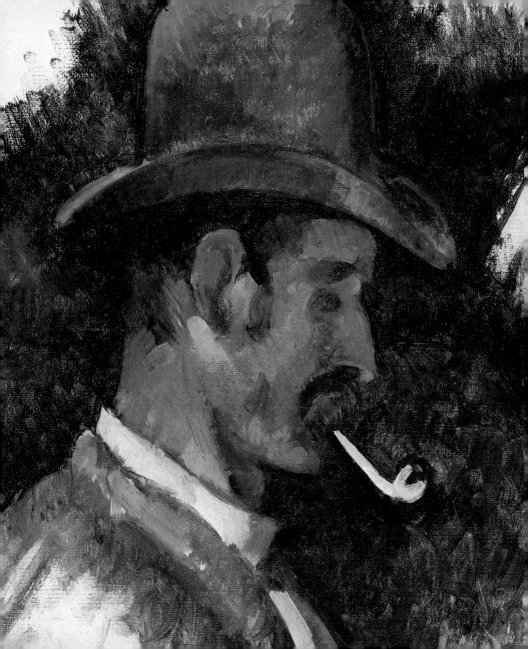

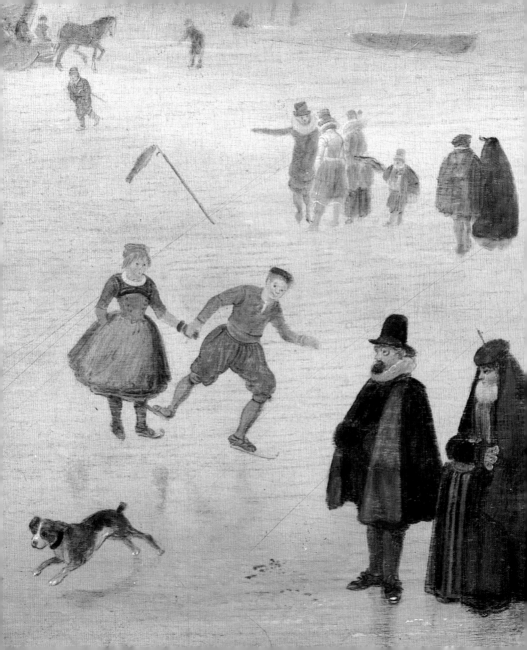

24

25

26

27

28

Hendrick Avercamp: *A Scene on the Ice*
c. 1625. 15½ x 30⅜". Ailsa Mellon Bruce Fund.

Aug./Sept.

29

30

31

1

2

Paul Cézanne: *Houses in Provence*
c. 1880. 25⅝ x 32". Collection of Mr. and Mrs. Paul Mellon.

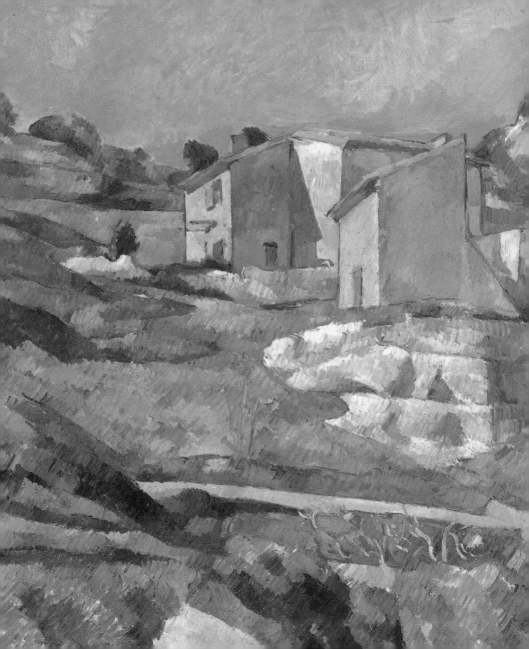

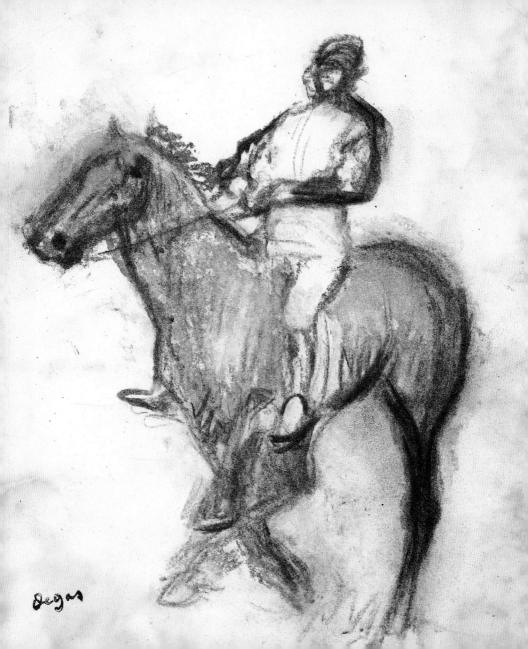

September

3

4

5

6

7

Edgar Degas: *Jockey*
c. 1898. 11 x 8¼". Gift of Mrs. Jane C. Carey
for the Addie Burr Clark Memorial Collection.

September

8

9

10

11

12

Raphael: *Bindo Altoviti*
c. 1515. 23½ x 17¼″. Samuel H. Kress Collection.

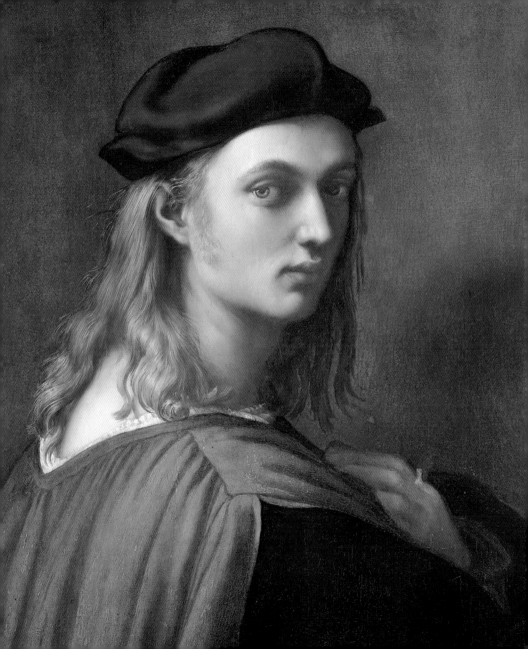

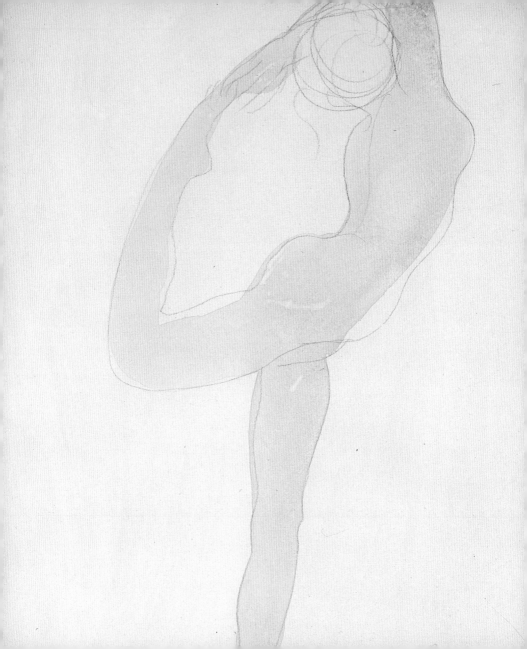

September

13

14

15

16

17

Auguste Rodin: *Dancing Figure*
Signed, c. 1900 - 1905. 12¼ x 9¾". Gift of Mrs. John W. Simpson.

September

18

19

20

21

22

Auguste Renoir: *Oarsmen at Chatou*
Signed, 1879. 32 x 39½". Gift of Sam A. Lewisohn.

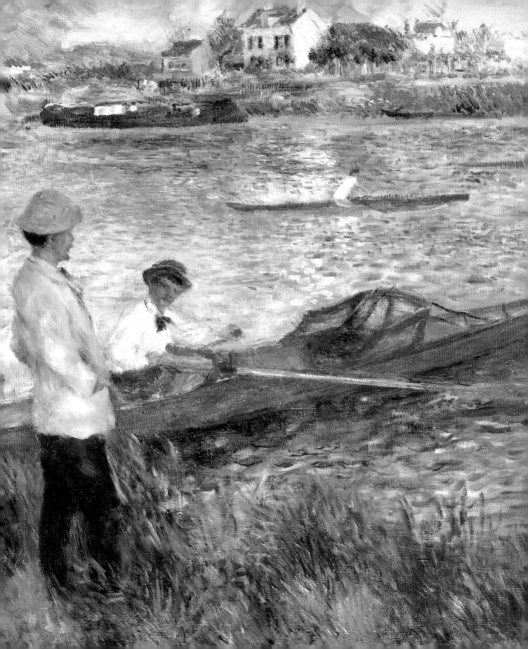

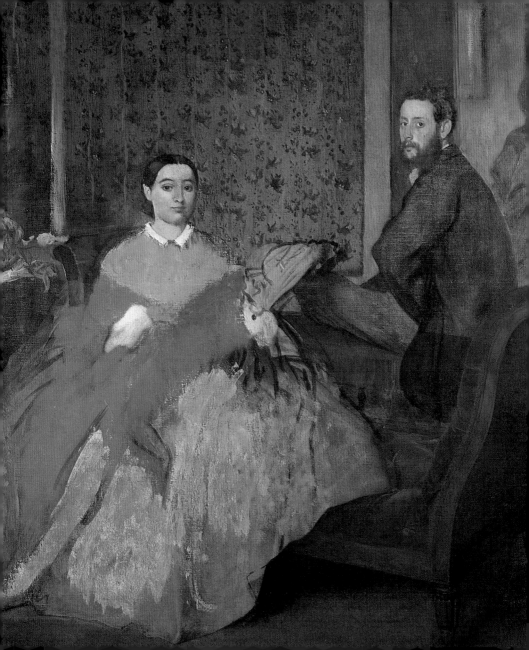

September

23

24

25

26

27

Edgar Degas: *Edmondo and Thérèse Morbilli*
c. 1865. 46⅛ x 35⅜". Chester Dale Collection.

Sept. Oct.

28

29

30

1

2

Jan Vermeer: *Woman Holding a Balance*
c. 1657. 16¾ x 15″. Widener Collection.

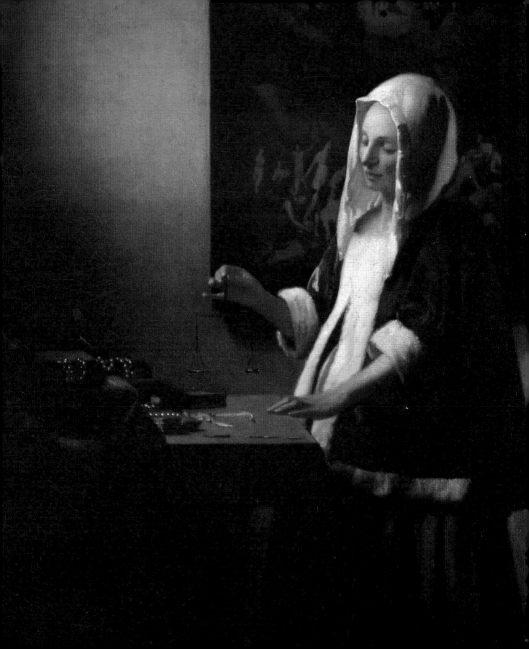

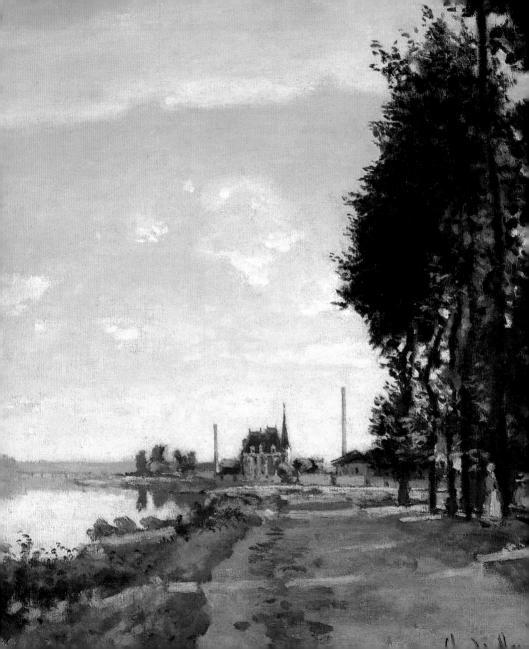

October

3

4

5

6

7

Claude Monet: *Argenteuil*
Signed, c. 1872. 19⅞ x 25⅝". Ailsa Mellon Bruce Collection.

October

8

9

10

11

12

Camille Pissaro: *Peasant Girl with a Straw Hat*
Signed, 1881. 28⅞ × 23½". Ailsa Mellon Bruce Collection.

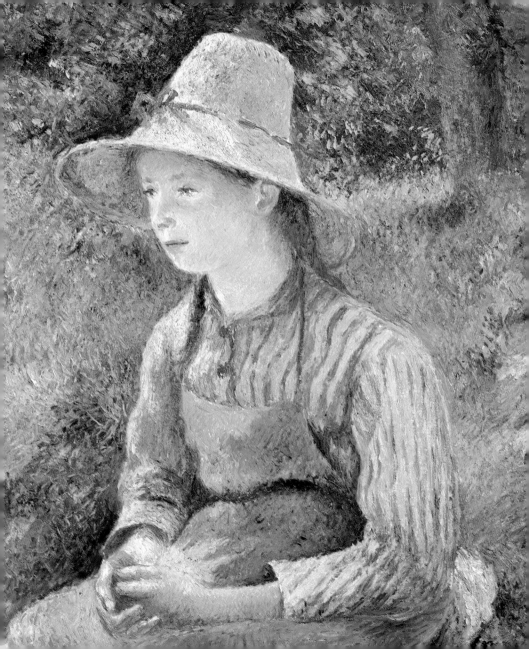

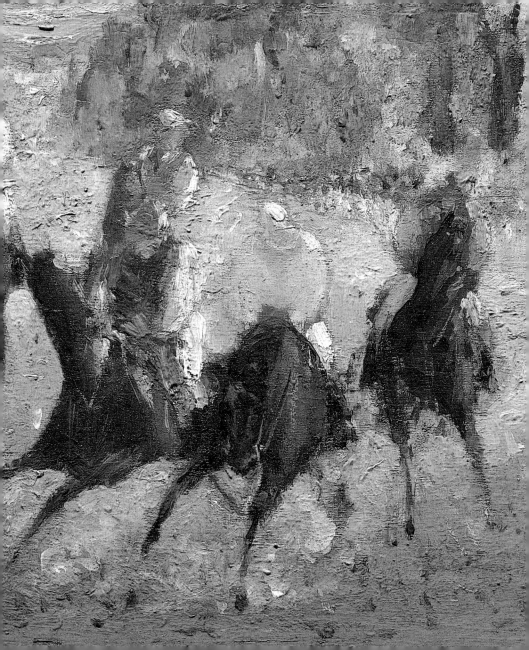

October

13

14

15

16

17

Edouard Manet: *At the Races*
Signed, c. 1875. 5 x 8½''. Widener Collection.

October

18

19

20

21

22

Pierre Bonnard: *The Artist's Sister and Her Children*
Signed, 1898. 12 x 10". Ailsa Mellon Bruce Collection.

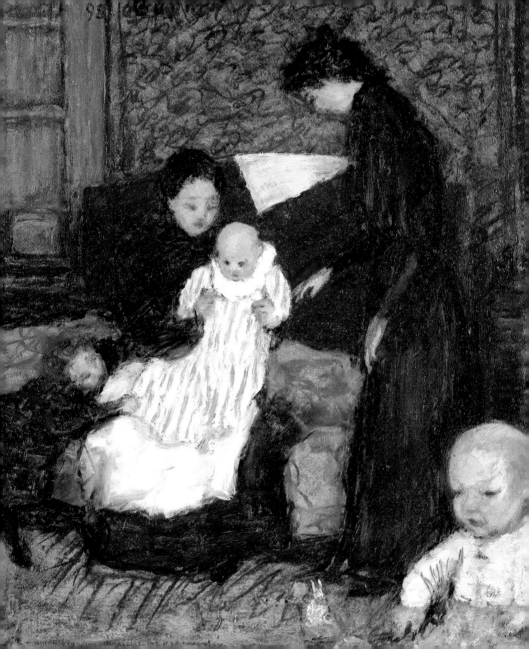

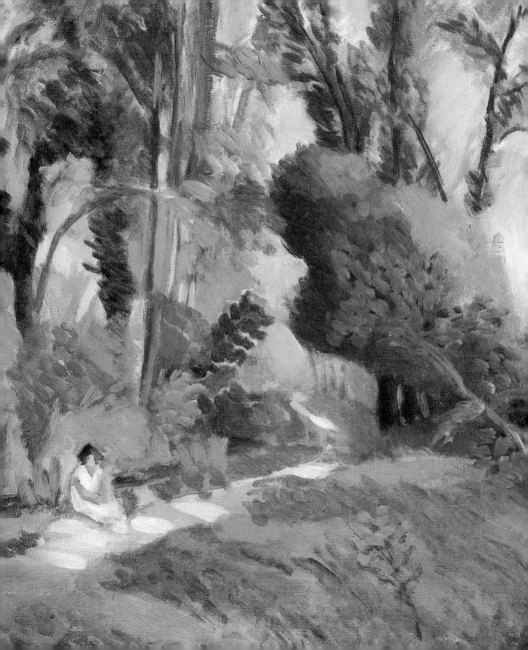

October

23

24

25

26

27

Henri Matisse: *Les Gorges du Loup*
Signed, 1920/1925. 19¾ x 24″. Chester Dale Collection.

Oct./Nov.

28

29

30

31

1

Pierre Bonnard: *The Letter*
c. 1906. 21⅝ x 18¾". Chester Dale Collection.

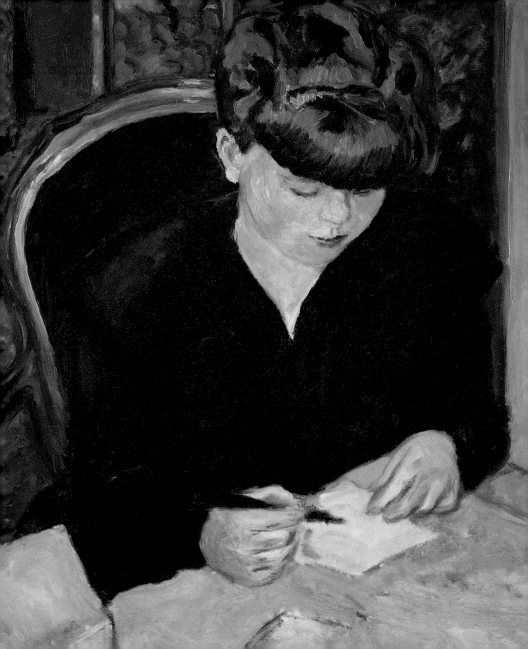

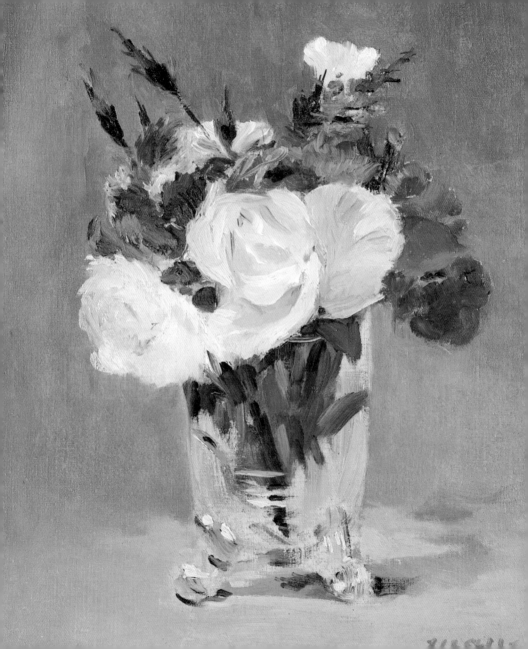

November

2

3

4

5

6

Edouard Manet: *Flowers in a Crystal Vase*
Signed, 1882. 12 2/8 x 9 5/8". Ailsa Mellon Bruce Collection.

November

7

8

9

10

11

Anonymous American: *Cat and Kittens*
c. 1872/1883. 12 × 13⅞". Gift of Edgar William and Bernice Chrysler Garbisch.

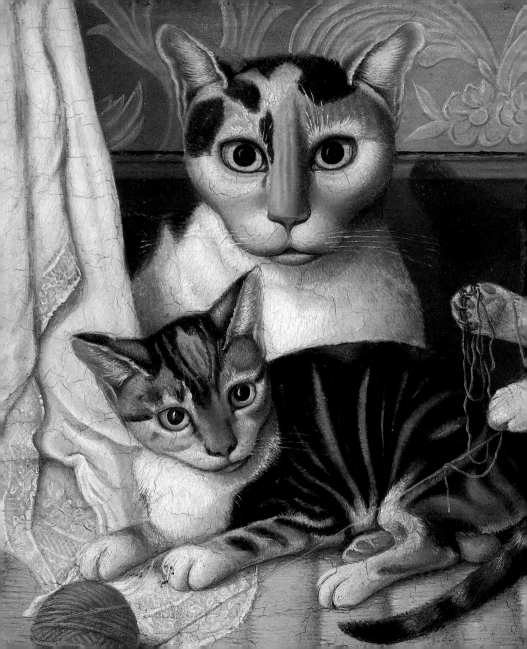

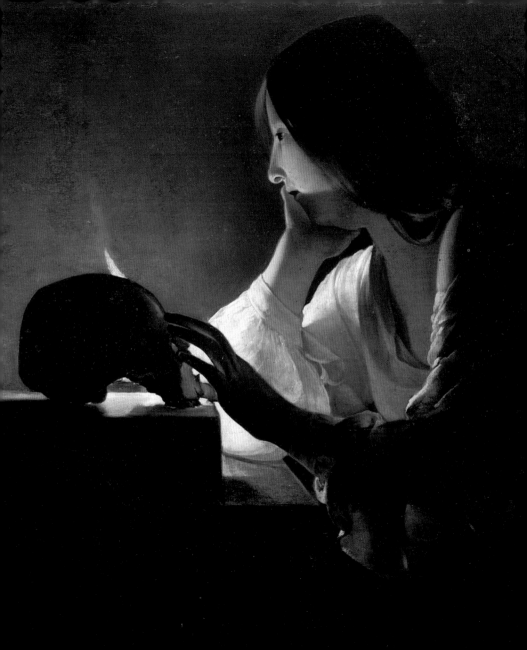

November

12

13

14

15

16

Georges de La Tour: *The Repentant Magdalen*
c. 1640. 44½ x 36½″. Ailsa Mellon Bruce Fund.

November

17

18

19

20

21

Pierre Bonnard: *A Spring Landscape*
c. 1935. 26⅝ x 40½". Ailsa Mellon Bruce Collection.

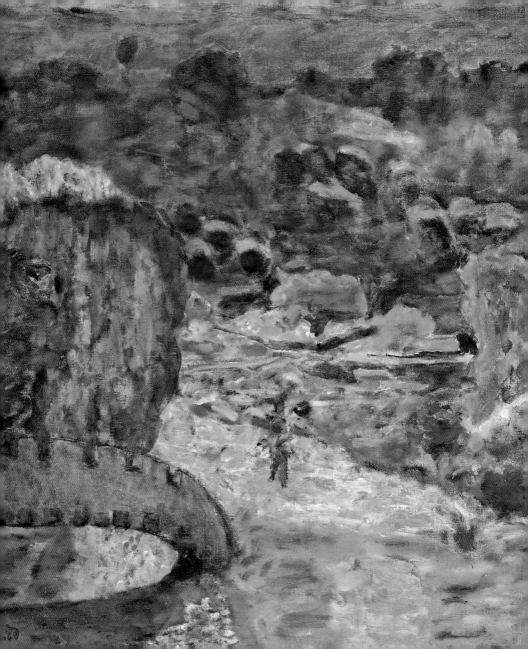

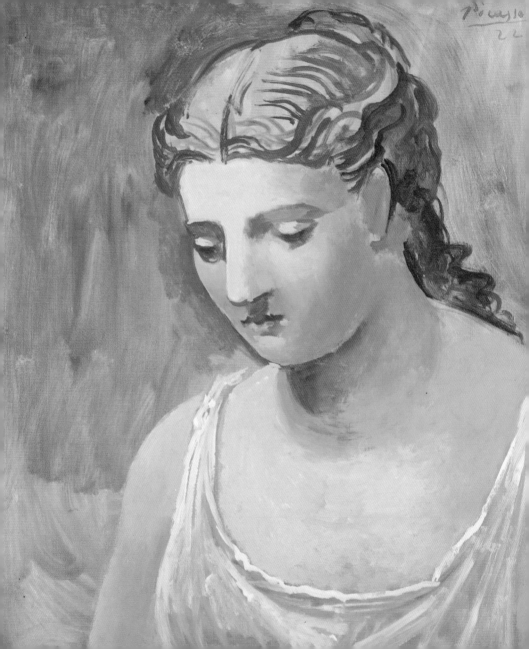

November

22

23

24

25

26

Pablo Picasso: *Classical Head*
Signed, 1922. 24 x 19¾". Chester Dale Collection.

Nov./Dec.

27

28

29

30

1

Claude Monet: *Banks of the Seine, Vétheuil*
Signed, 1880. 28⅞ x 39⅝". Chester Dale Collection.

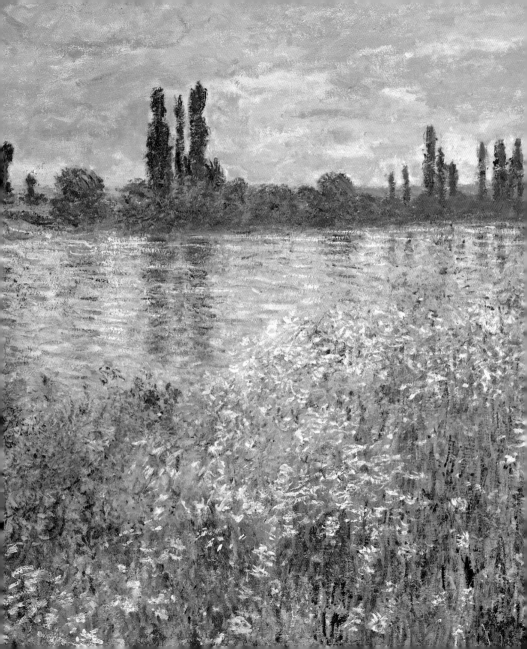

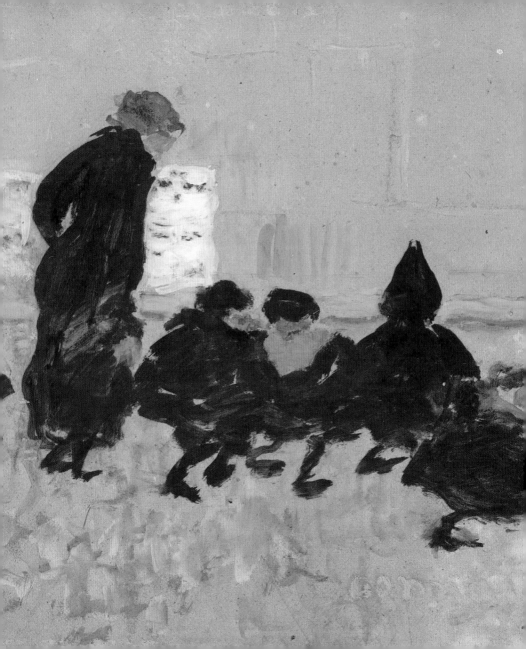

December

2

3

4

5

6

Pierre Bonnard: *Children Leaving School*
Signed, c. 1895. 11⅜ x 17⅜". Ailsa Mellon Bruce Collection.

December

7

8

9

10

11

Gilbert Stuart: *Commodore Thomas Macdonough*
c. 1818. 28½ x 23". Andrew W. Mellon Collection.

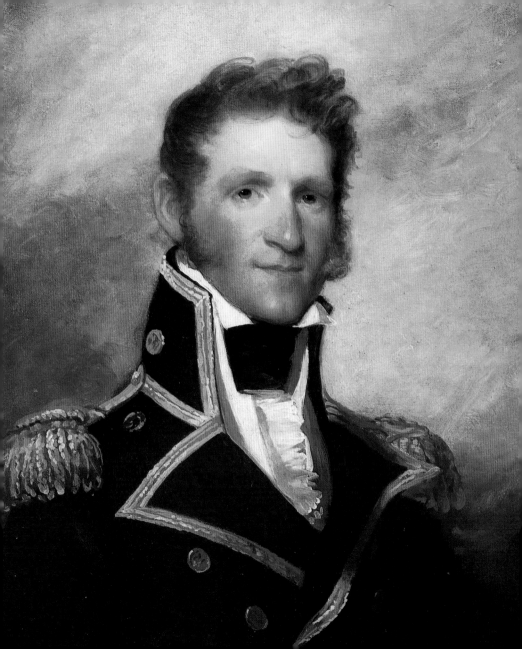

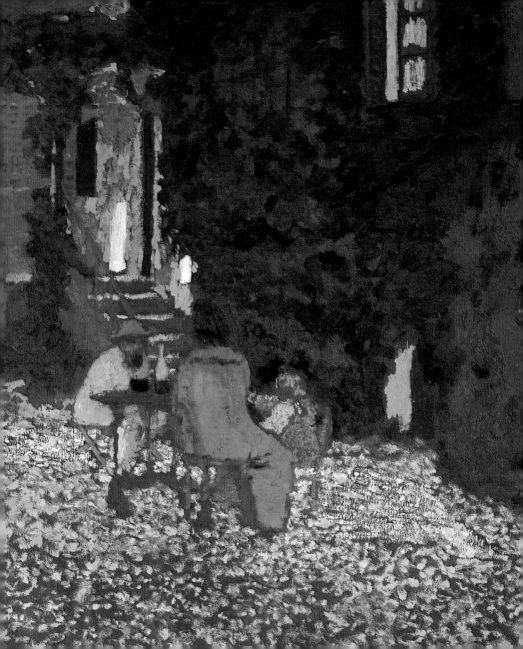

December

12

13

14

15

16

Edouard Vuillard: *Repast in a Garden*
Signed, 1898. 21⅜ x 20⅞". Chester Dale Collection.

December

17

18

19

20

21

Winslow Homer: *Breezing Up*
Signed, 1876. 24⅛ x 38⅛". Gift of the W.L. and May T. Mellon Foundation.

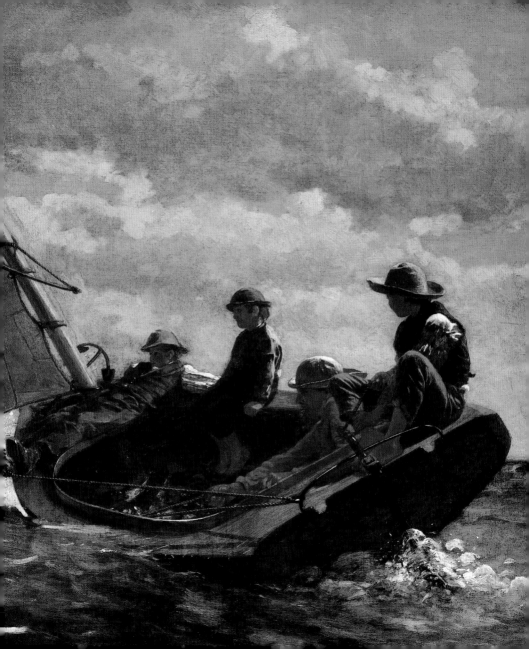

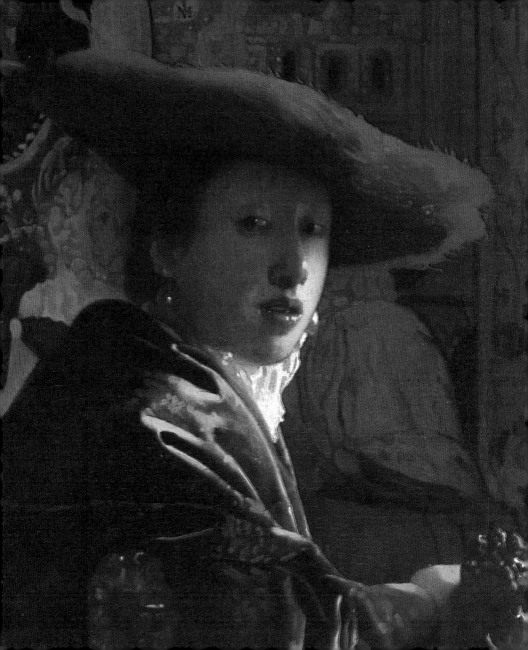

22

23

24

25

26

Jan Vermeer: *The Girl With the Red Hat*
c. 1660. 9⅛ x 7⅛″. Andrew W. Mellon Collection.

December

27

28

29

30

31

Edgar Degas: *Woman Ironing*
Signed, 1882. 32 x 26″. Collection of Mr. and Mrs. Paul Mellon.

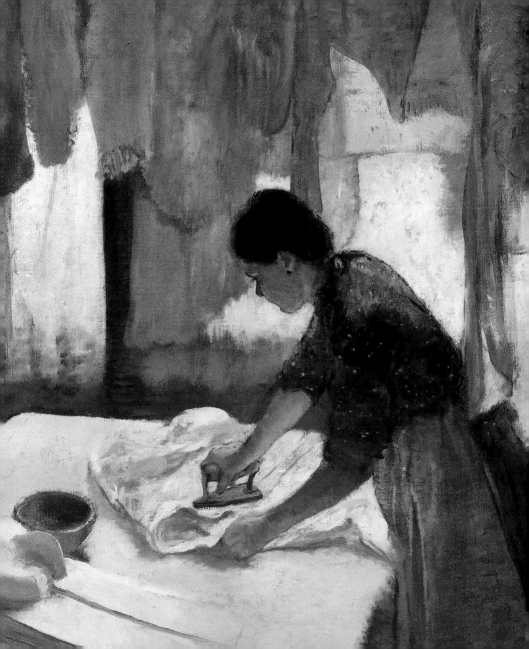

Index

Notes